T0150161

Claude Cahun

The Soldier with No Name

Claude Cahun

The Soldier with No Name

Gavin James Bower

Winchester, UK
Washington, USA

First published by Zero Books, 2013
Zero Books is an imprint of John Hunt Publishing Ltd., Laurel House, Station Approach,
Alresford, Hants, SO24 9JH, UK
office1@jhpbooks.net
www.johnhuntpublishing.com
www.zero-books.net

For distributor details and how to order please visit the 'Ordering' section on our website.

Text copyright: Gavin James Bower 2013

ISBN: 978 1 78099 044 6

A CIP catalogue record for this book is available from the British Library.

Design: Stuart Davies

Printed and bound by CPI Group (UK) Ltd, Croydon, CR0 4YY

We operate a distinctive and ethical publishing philosophy in all
areas of our business, from our global network of authors to
production and worldwide distribution.

CONTENTS

Foreword

My name's Gavin, and I'm a Cahunian.

My addiction to The Artist Formerly, and indeed *Formally*, Known As Lucy Renée Mathilde Schwob dates back to 2004. I was asked to write a feature for *FLUX* magazine, on an exhibition taking place at the Manchester Art Gallery. The exhibit included a smattering of striking self-portraits taken by a lesbian surrealist turned resistance fighter with a penchant for Marxism and an androgynous pseudonym: Claude Cahun.

I did what any young journalist would and hopelessly over-researched the eight-hundred-word piece, reading everything I could get my hands on through the University of Manchester library. I was hooked. Here was an artist – not in the traditional sense perhaps, but in any case an individual whose life was her art and for whom the epithet 'artist' could be reasonably applied – who was practically unknown beyond the auspices of a handful of art historians, students and the narrowest of readerships; and yet Claude Cahun is, to my mind then and still years later, the most singularly fascinating creative spirit of the twentieth century. A writer of poetry and prose, self-centered curator of tableaux, a skilled sketch artist, photographer and muse, a *poseur*, actress and performer, composer of *objets d'art*, a propagandist and a saboteur – Claude Cahun was nevertheless all but forgotten by the time of her death, now nearly sixty years ago, and has only in the last two decades enjoyed something of a renaissance.

I've spent the past year attempting to discover not only how Claude Cahun vanished from history, but also the reason for her disappearing act. It's my contention that to be a Cahunian is to wish that status on everyone; to not stop until

her name resonates with more than just a handful of loosely connected enthusiasts. But that's not enough, for to do so demands a certain focus – a degree of understanding as well as context that transcends my arrogant notion that you, the reader, should know about Claude Cahun. I need to explain *why* you should know about her, not merely *what*.

As a writer my instinct, on beginning this search, was to concentrate on Cahun's literary output and strip away the art historical narrative that has built up around her photography – for it's with the latter that art historians have, if they are aware of Cahun at all, become preoccupied. What of her writing's place among the various tracts of Surrealism, or its merit in relation to her other influences? What of its context in the male-dominated canon of avant-garde literature? And what of the obvious comparisons to be made with other female writers working in Paris at the time – particularly those who comprised one half of a kind of lesbian literary power-couple, most notably Gertrude Stein (with Alice B. Toklas) and Adrienne Monnier (with Sylvia Beach)? These questions warrant an answer, but it should be provided elsewhere, in a work of literary theory, which this is not; further, to ask them in isolation is to render any study at all of Cahun futile. How can one separate out the works of an artist, effectively decide to pick and choose, while attempting to write something sensible about their art?

Indeed, a disproportionate amount of time has already been spent on only part of Cahun's oeuvre – not to mention her after-the-fact influence on the gender-politico debates of the seventies; the artist, stranded in historical No Man's Land, wasn't even known to her acolytes at the time. More still has been made of her time-continuum-defying one-upmanship when it comes to visual artists who would inadvertently mimic her, none more so than Cindy Sherman. The auto-portraits of each are eerily similar – noteworthy, if only for

their mutual exclusivity: Sherman was of course unaware of Cahun and, naturally, vice versa. A remarkable coincidence, but given this focus on Cahun's photography – putting aside the inconvenient truth that, as a cult artist, she has only enjoyed brief revivals of interest over the last two decades – scant attention has been paid to her writing. What's more, all this is despite the fact that her photography was not in the vast majority of cases intended for public scrutiny. Putting aside the images composed by Cahun for use in her literary works, along with one lithograph and illustrations for a 1937 children's book (*Le Coeur du Pic*, by Lise Deharme), *Frontière humaine* (*Bifur* 5, 1930) was the only self-portrait published in Cahun's lifetime.

Still, to ignore Cahun's visual output in order to pigeon-hole her as *just* a writer would tell only half the story – perhaps more, but in any case not all. In appreciating what makes Cahun worthy of anyone's time after all these years we cannot have one without the other. Further, to pay no attention to her photography whatsoever would be downright idiotic; some of her work is astonishing – and all of it deserving of an audience. After all, by experimentation with costume, make-up and pose, by manipulating the existing categories of identity and defying the boundaries of established femininity, by fusing the traditional subject-to-object dichotomy, and by placing herself firmly at the centre of her work, Cahun challenged the surrealist conception of 'woman' in ways never before seen. Though this has been amiably argued elsewhere – and here is not the place to expend yet more energy illustrating the fact – she is certainly worthy of greater fanfare solely as a visual artist.

Through every medium she employed, Cahun was willfully narcissistic in her quest for self-identity. As the centre of her own work, she refused to submit either to narratives or preconceived relationships of subject to object, while

she returned the scrutiny of her audience – and, indeed, her own investigations – with uncompromising effrontery. She sought to reflect rather than deflect, and never shied away from what was for her an unanswerable question: *Who am I?* Rather than attempting to solve the mystery of Claude Cahun – by positing her, explaining her, and thereby somehow understanding her – we would be advised to ditch our agendas, strip away the art historical narrative, and follow her lead.

Cahun was far from prolific. Of the work that survived her tumultuous lifetime and the passing of years since her death, the question of authorship – not to mention target audience – is by no means in all cases clear. She was the most unreliable of narrators, disingenuous, dissembling and deliberate in subsuming her identity while, on the surface at least, attempting to reveal it. And yet, none of this matters – because to be a Cahunian is akin to addiction: to art for art's sake; to the most unknowable of all things; to a life lived without compromise, with courage and conviction. When Marcel Duchamp said 'my art is that of living', he was talking about individuals like Cahun – for her life was a remarkable one, and a masterpiece unparalleled by anything she would ever produce on paper or through the lens of a camera. To us Cahunians, Claude Cahun *is* art.

Claude Cahun:

The Soldier with No Name

Claude Cahun née Lucy Schwob was born to a wealthy literary family in Nantes on the 25th of October 1894. While the Schwobs were Jewish, her father and uncle were agnostic, her mother Catholic.

In 1876 Cahun's paternal grandfather George Isaac Schwob arrived in Nantes and acquired the regional newspaper *Le Phare de la Loire*. He himself had schooled with Gustave Flaubert, wrote intermittently, and worked in foreign affairs before moving to Nantes. With time, the paper's reach increased, in 1892 George died, and Maurice, Cahun's father, took over – which further extended the paper's readership.

Cahun's uncle, the writer Marcel Schwob, was born in 1867. In 1882 he was sent to Paris to lodge with Léon Cahun, his maternal uncle and keeper of the Bibliothèque Mazarine. While enrolling at the Sorbonne, in 1888 Marcel published novellas in *Le Phare de la Loire*, and in 1891 he befriended a poor, sickly prostitute, who would become his 'Monelle' in the infamous *Le Livre de Monelle*, published in 1894. The book was cited by the surrealist André Breton as one of his favourites. Indeed, Schwob also influenced Guillaume Apollinaire – the man who would coin the term 'surrealism' – having met the young poet in 1900. Both well connected and well liked, Schwob corrected the final draft of his close friend Oscar Wilde's *Salome*, and also translated Daniel Defoe's *Moll Flanders*. He died in 1905.

Cahun was a *fin de siècle* lottery winner, who inherited an intellectual fortune as part of a great, if incestuous, literary dynasty. She was also a Jew. In 1906, at the height of the Dreyfus Affair and amid growing anti-Semitism in France,

Cahun was schooled in Surrey for two years – where she was nonetheless bullied for her Jewishness. She would never attain fluency in English either, a fact that renders her work all the more difficult for those of us not able to confidently read French. Her letters frequently included corrections made by Marcel Moore (née Suzanne Malherbe), Cahun's step-sister and eventual lover. While her childlike writing belied a comprehensive knowledge of literature acquired during an upbringing rich in literary influences, this ostensible child-ishness would remain. There was a lifelong attempt in her art to evoke *le merveilleux* – dressing up and toying playfully, though seriously, with her identity – that rendered Cahun an acolyte of Breton before she had even met him. As she declared towards the end of her life, 'I have always been a surrealist.'

Her inchoate position, however, was symbolist. In his writings Marcel Schwob questioned the relation between self and self, or self and other, without a reference point – or mirror. He was for Cahun a role model, though from an early age she would grapple with her lineage and with the legacy of Symbolism. She even considered her uncle egotistical, which was a supreme irony. Like the *égoïste* Cahun, Marcel was confrontational; he once challenged a particularly vehement critic of Wilde to a dual. But Cahun, naturally, had more in common with her uncle than she would care to admit. She sought to negate the authentic singular subject – a pursuit for aesthetes and symbolists – and was opposed to realism, to tropes and generality. If for Cahun literature was masquerade, then her uncle's *Le roi au masque d'or* was its apotheosis – the common denominator in the work was a malformed body, also evoked in Cahun's 1930 anti-memoir *Aveux non avenus*. Marcel died when Cahun was just ten years old, his true character remaining, for her, elusive – a second irony, for she too would later utilise masks in her art, while never quite

being able to avoid stumbling as a result of those employed by her uncle.

André Breton, who deemed madmen oracles, would surely have found Cahun's childhood enthralling. Her mother Mary-Antoinette had her first fit of madness when Cahun was just four years old. The ordeal was traumatic, understandably. Hospitalised, her mother was then finally interned in a Parisian psychiatric clinic, where she remained until her death. The child was effectively raised by her paternal grand-mother Mathilde Cahun – from whom she eventually took the second half of her pseudonym. She died in 1907, and as Cahun grew into a young woman tensions ran high in the household. Cahun's father, who by all accounts failed to understand both her intellect and sexuality, remarried in 1917 the mother of Marcel Moore. The two girls Cahun and Moore, already close, became inseparable, and moved into a small apartment above *Le Phare de la Loire*. Her father opposed the move, but could do little to stop it.

In the apartment the two girls lived as lovers. An early self-portrait of Cahun in a Medusa-like pose – strands of hair enveloping her face as she lay in repose, head on a pillow – intimates an undeniably sexual attraction between Cahun and her audience, who in this, if not every case, was Moore. Indeed, it is the intimacy of the portraits – coupled with how few were ever publicly displayed – that suggests Cahun's visual output was intended to remain, if not entirely clandestine, then for certain eyes only. The role of Moore in the self-portraits is unclear. Was she instrumental in pressing the button, as it were, or was she the intended audience and nothing more? To consider that these self-portraits are not self-portraits at all, but rather the product of collaboration, is to render the couple an object of lesbian subject designed to evaluate existing norms, including supposed surrealist misogyny. Deliberately non-conformist (and lesbian), the

attempts to subvert the hetero paradigm were not, however, widely distributed – a curious paradox, given the potency of the images. These early, youthful portraits – all about desire and lust, and seemingly designed to attract the attention only of Moore – were the contemporary equivalent of sexting.

Cahun of course contributed to *Le Phare* around this time, and, between 1918 and 1921, was one of only three main contributors to her father's journal *La Gerbe*; she wrote for as many as thirteen issues during its short-lived existence. She was in fact the only woman published in *Mercure de France*, a celebrated Parisian review and a favourite of her uncle, and wrote literary articles on Pierre Benoit, André Gide, Marcel Schwob and Adrienne Monnier. Indeed, she visited the latter's Paris shop La Maison des Amis des Livres, in the rue de l'Odéon, when it opened in November 1915.

'Her face like that of a little bird of prey,' wrote the surrealist Marcel Jean, describing Cahun. Her appearance was certainly startling. She shaved her head to the bone in 1916 – a fashion among the avant-garde, even if the story that legendary flapper Coco Chanel started the trend was just that: a legend. Still, in *The Autobiography of Alice B. Toklas* Gertrude Stein joked that, by the late twenties, only she and Elisabeth de Gramont, Duchess of Clermont-Tonnerre, remained in Paris as women with long hair. After 1919, the undeniably punkish Cahun would frequently dye her crew cut pink and green, stain her skin, and wear outrageous, distressed or dyed clothing. It was a time that saw Victor Margueritte popularise a new feminine type in his bestselling *La Garçonne*. Similarly Otto Weininger's 1903 work, *Sex and Character* – lauded by Stein – argued that the ascendance of a woman depended on how masculine she was. In this fashionable period to be a lesbian, however, celebrities (Stein, H.D., Radclyffe Hall) were intermingled with the forgotten.

It was a vital time – the growing women's suffrage

movement on the one hand, Colette editing French *Vogue* on the other – and Claude Cahun was living at the heart of it.

*

In 1919 the Paris-based publisher Editions Georges Cres published Claude Cahun's *Vues et visions*, a collection of symbolist-inspired meta-narratives that had previously appeared in *Mercure de France* in May 1914.

The prose poems comprising *Vues* are divided into two. The 'view' is invariably a scene set at Le Croisic, a popular seashore resort eighty kilometres from Nantes where the Schwob family holidayed. While the work first appeared in 1914, it's clear from the first poem that work started in 1912. The collection, a public and artistic coming out given its charged content, was dedicated to and illustrated by Moore. Here, Cahun is unequivocal in her attempt to escape earlier influences – especially, and paradoxically given the form, symbolism. G. Albert Aurier, a poet and devotee of the movement, outlined its five criteria as early as 1891 – *idéiste*, *symboliste*, *synthétique*, *subjective* and *décorative* – and Cahun set out to expose this method; first, in *Vues et visions*, and later in *Les Jeux Uraniens*. The result of the former, though clearly symbolist and with a resemblance to Baudelaire, involves the creation of an overt juxtaposition between view and vision.

The disharmonious nature of the public vis-à-vis the private, and the clash of concomitant impulses, is evident in much of Cahun's early writing – its focus, though never explicitly stated, was her homosexuality. In the unpublished 'Amor Amiciate' ('The Love of Friendship'), writing as Daniel Douglas, Cahun wrote in the preface of 'the love that dare not speak its name' – a line by Wilde's treacherous lover, Lord Alfred Douglas, pertaining to homosexual love. Cahun's aestheticism was visual; Wilde's, too, not exactly confined to

his writing. The dandy, after all, was parody – but Wilde's trial was a trial of homosexuality, which his appearance came to signify. His 1894 play *Salome*, originally written in French, was banned for depicting biblical characters. Some feared that they could be transformed into homosexuals simply by watching it.

Cahun attended a hearing relating to the play's performance in London in 1918, where she first saw Douglas (she would subsequently adopt his name between 1918 and 1920). She wrote about the proceedings for *Mercure* and later dedicated a version of the story, 'Salomé la sceptique' in her 1925 work *Héroïnes*, to 'O.W.' – taking on its connotations of the castrating woman and unrequited (read: homosexual) love. In Cahun's version, however, the protagonist transcends desire and difference. Cahun has no desire for the head – or the phallus – for her protagonist is an actress rather than the biblical figure, a stand-in or double for the 'real' thing.

Parts of *Héroïnes* were published in *Mercure de France* in 1925, but the work wasn't published in full during Cahun's lifetime. It was discovered in Jersey, several years after her death, at the bottom of a box – and the work was only published in its entirety in 1999. Seven of its sixteen texts were first published in *Mercure* in February 1925, and two appeared in *Le Journal Littéraire* later that month. Cahun's heroines are othering. In Salomé's case her lesbianism is outside signification – as other – and confirms the parody while protecting the reality: lesbian desire remains intact. In 'Sappho l'incomprise', Cahun subverts identity – Sappho's latent lesbianism – to protect the myth of her heterosexuality. Lesbianism is therefore her 'undoing'. For Cahun, lesbianism undermines the supposed dichotomy between pure and impure on which all art is founded and judged. By rejecting the either/or modalities of contemporary sexual discourse – and, indeed, prevalent norms – the artist, at least in this case, remained complete.

Cahun's sexuality as badge of honour, though always subtle, can be traced to earlier self-portraits – none more so than her 1915 rendering of a serene sailor girl, which channels Tadzio from *Death in Venice*. She was already writing for Henri Lefebre and Pierre Morhange's *Philosophies*, lifelong friend Henri Michaux's *Le Disque Vert*, and the avant-garde homosexual review *L'Amitié*. She had until then written under various pseudonyms, including Claude Courlis and R.M. (short for Renee Mathilde, her middle names). Cahun also used 'Rene', taken from her cousin who'd died in 1917 – an article in *Mercure* was signed thus in 1921. She had written the unpublished *Les Jeux Uraniens* – pertaining to the uranian 'third sex' – around 1914. Dating the work has proved difficult, however: Cahun's sole biographer François Leperlier originally placed it between 1916 and 1919 and later moved its genesis to 1913-14. Leperlier also dates Cahun's first use of her preferred pseudonym to 1917, which roughly coincides with her decision to shave her head and not with the writing of *Uranian Games*. No matter the work's provenance; consisting of one hundred and ninety-eight verses over ninety-four typewritten pages, with an English warning that TRESPASSERS WILL BE PROSECUTED, it was never finished. In 'Marcel Schwob', published in 1920 in *La Gerbe*, Cahun addresses the elephant in the room. She dismisses literary work as a source of information on the writer and considers it a masquerade, arguing that only more personal accounts like travelogues will suffice; this provides more than an intimation as to her artistic temperament, and has been the source of frustration for Cahunians ever since.

Sapphic, emblematist, comprising a rearranging and replacing of text, *Les Jeux Uraniens* was playful and subversive – Cahun's first attempt towards a verbalisation of her concerns over multiple identities, and the next stage in her move away from symbolist influences. Back in 1914 Cahun

had started studying literature and philosophy at the Sorbonne in Paris. The course was supervised by M. Brunschvieg, the aim of which was 'the explanation of philosophical authors'. In her personal life Cahun was unhappy. She frequently harboured suicidal thoughts and was diagnosed anorexic. In 1917, when she and Moore moved above *Le Phare*, Cahun was able to briefly overcome her health problems – never fully, for they would torment her throughout her adult life and ultimately lead to her premature death.

These early texts evoke themes of appearance and the regulation of behaviour in public – and, crucially, her work is progressive: in 'Marcel Schwob', she deduces that his character could not be discovered through his writing; in *Vues et visions*, meaning assigned to everyday objects is subjective; and with her article on Oscar Wilde, the social restriction of discourse on sexuality is revealed – and the need to find the right key, as with her uncle's character, demonstrated.

It is her refusal to be fixed by genres or styles that most especially characterises this early period in her life – not merely her obsession with the superficialities of identity. This explains the dearth in material generated in the early twenties, a fecund time for every Parisian artist and her dog. But between 1921 and 1925 Cahun published little if anything of note. While preparing *Héroïnes* she wrote for only a handful of journals, even though the couple moved to the literary melting pot that was Montparnasse in 1922. Cahun was nevertheless drawn to Monnier's bookshop – where Breton and Louis Aragon read – and was responsible for a 1919 photograph of Monnier's partner Sylvia Beach, taken when Shakespeare & Company opened across the street. Cahun might have even worked with Beach in her shop. A regular visitor certainly during this period, registration card 'no.117' was made out to Cahun for Monnier's shop, and her friendship with the couple

would last until the end of the decade.

Cahun's limited literary output aside, she and Moore did choose to immerse themselves in all aspects of metropolitan performance and artistic life while in Paris. Aside from the various guises adopted in her self-portraits, Cahun adhered to the philosophy of Les Amis des Arts Esotériques and performed at the Théâtre Esotérique, under the direction of the dramatist Pierre Albert-Birot, as well as with Le Plateau – Cahun working principally as a performer, and Moore as a designer. Cahun did not, however, fully integrate herself with the city's inter-war lesbian elite – which included Beach and Monnier, as well as Romaine Brooks and Djuna Barnes. The latter's 1928 lesbian satire, *Ladies Almanack*, which was part-financed by Natalie Barney, joked about ladies with monocles believing in spirits. Wilde and his contemporaries had informed the *fin de siècle* lesbian milieu, but a new generation of women influenced this new elite, most notably Colette, Radclyffe Hall – whose 1928 lesbian novel, *The Well of Loneliness*, was banned – and Stein. Even so, the hugely influential *Women of the Left Bank* by Shari Benstock fails to mention Cahun even obliquely – an omission at least in part due to her failure, for whatever reason, to finish what she started.

Her marginality goes some way to explaining her absence – but was this marginality forced on her as the result of her sexuality, her status as 'androgyne', or chosen? In interwar France homosexuality was no longer confined to an elite group of 'inverts'. Though high society lesbians like Barney were said to exert control over others, to be an affluent lesbian in twenties Paris did not denote pariah status. Indeed, even a 'homosexual literature' had been born. *Inversions*, a homosexual revue, opened in 1924 but was closed by police, before reopening in 1925 as *L'Amitié*. In a case of art mirroring life, however, in 1928 the surrealists carried out an 'investi-

gation' into sexuality, and concluded that there was an ideal 'natural' heterosexuality directly opposed to bourgeois 'perversion': essentially, male homosexuality. It was therefore possible to be considered deviant even among the avant-garde, though according to Georges Bataille Breton was more bourgeois than the bourgeoisie – a sentiment echoed by feminist art historians ever since.

An outsider among outsiders, perhaps, the alternative infuses all of Cahun's work, and disguise is rendered all the more important. Her 1926 essay 'Le Carnaval en chambre' meditates on masks. Levi-Strauss wrote of masks as defined by what they transform or choose not to represent; in this way, masks enforced social cohesion. For Cahun, however, the reverse is true – she interrupts codes and identities, de-constructs and disengages.

In *Héroïnes*, historical characters are inverted – and Cahun's first, fully realised authorial masquerade is created. The opening page evokes *Legendary Moralities* by Jules Laforgue – published in *Mercure* in 1897 – which describes Ruth as 'the unfortunate and typical heroine'. Taking this further, Cahun's 'Eve the too credulous' is addressed to Eve – or the 'Evettes'; in general: 'To all young girls, past present and future.' Some of the text is in English. Thanks to Eve, Cahun writes, 'all the apple-eaters' had learned that Good and Bad existed – 'but equally tormented, they cannot recognise Which is Which'. Suffering for one's sins is at the heart of this, a work by an anorexic weighed down by her struggle with self. Again, in 'Delilah, woman among women' Cahun's Delilah forces Samson to shave his head – then pushes him away when she realises he has lost his powers. As punishment, she has herself circumcised. 'The sadistic Judith' posits a Judith 'shut away' and fasting. She doesn't want to be judged for her acts. 'What do we have in common?' she pleads, echoing Cahun's disregard for the attention of others. 'The joy of a crowd has a

thousand mouths – and no ears.' The public gaze, like the scrutiny of her peers, is unforgiving. In 'Sappho the misunderstood', she writes, caught between wanting to fit in and flee: 'I don't know where I'm running, for two thoughts are within me...' Cahun's Sappho hides her true desire then fakes her death – to become a lesbian siren. Cahun is playful, while also plagued. Her Cinderella – 'Cinderella, humble, haughty child' – she muses: '... perhaps I could truly love him [the prince] if he wanted sometimes to reverse roles'. This is then rejected. 'I must deceive him to the grave.' After all, she surmises ruefully, 'What's important is to be princess.'

Incest, lesbianism, the androgyne – all are cited in this, her most ambitious work to date. Symbolism, too, is parodied. In 'Sophie the symbolist', Cahun writes: 'When one began with the symbol, one had little taste for the thing itself.' This is a tale of a now indifferent girl, no longer interested in her childhood lover; for Cahun, that of symbolism. Hermaphrodite, Cahun concludes, is deceitful. 'All heroines are liars – and she would not admit that she, too, started a virgin. She had already known herself, deflowered, at her mother's breast.' Though the work reifies the hero – John the Baptist is referred to as 'Whatshisname?' – Cahun is speaking through these women as masquerade; this is a Nietzschean exposition of the relativity of representation that resembles his *Umwertung aller Werte* or transvaluation of values. If all heroines are liars then so, too, is the artist who conjures and (re)creates them – the value of the very endeavour is stripped of any meaning whatsoever. The visual and the literary are intricately linked: her *Héroïnes* is written in the tradition of Ovid's 'Heroides', although Cahun utilises hearsay to negate the victimhood at the heart of their shared mythology. She renders them *not* sacred and champions, above all, the anti-hero.

*

For Cahun, who revelled in ambiguity and sought disruption – in life and in art – to reconceptualise the self was to reconceptualise society. Her labels were opportunities, which was in stark contrast to an altogether more accessible (not to mention famous) memoir of the time.

The Autobiography of Alice B. Toklas was Gertrude Stein's first and only explicit attempt to write commercially, and the success of this pursuit was perhaps all the evidence her self-declared genius needed. Indeed, written in a knowing, chatterbox style, Stein usurps the identity of her lover Toklas – who is subservient intellectually if not in other areas of the domestic arrangement – to declaim her mastery. This is a form of self-assuredness that Cahun cannot and does not match in her 1930 work *Aveux non avenus*, a broken narrative with neither object nor subject. Even when compared to Stein's other works, with their famously abstruse prose, *Aveux* is at times unreadable. And deliberately so, for if Cahun could not know herself then, she surmises, why should we?

Cahun's use of the mirror in both her visual and literary work was an investigation into her own narcissism. It was the same with memoir. While Freud saw homosexuality as autoerotic – i.e., sex with oneself – the psychologist Havelock Ellis argued that there were two roles at the heart of homosexual relationships, and a choice between which to adopt. Cahun, too, believed in such a thing as twin homoeroticism – two bodies; two souls. In 1929 she translated Ellis's *Woman in Society*, which was published in *Mercure*. Though his 'third sex' – a type that was neither male nor female and drew from each without rejecting difference – undoubtedly appealed to Cahun, as demonstrated in *Uranian Games*, she nevertheless repeatedly refused to directly address her own sexuality through art. Joan Riviere's seminal 1929

essay, 'Womanliness as a masquerade', states that women who wished for masculinity put on a mask of womanliness as a 'defence' – this was the Oedipus complex in women. A sort of femininity as dissimulation, the work echoes Nietzsche's contention that, for woman, everything is mask – as he put it, 'Woman is so artistic.' For Riviere sexual identity, too, is a construct – and a masquerade. By insisting, without exception, that this is always the case with intellectual women, Riviere's 'masquerade' denies woman any identity at all. And, while some sexologists argue that a lesbian is not a woman, but instead refuses definition, Lacanian theory goes further: all gender roles are, like womanliness for Riviere, pretence.

The same can be applied to memoir – 'There is no such thing as autobiography,' according to Jeanette Winterson, 'there's only art and lies' – and it is the attempt to fix and reflect a particular image of Cahun that is most contentious among Cahunians. As Cahun wrote in *Aveux non avenus*, '"Mirror", "fix", these are words that have no place here.' The preface to *Aveux* (or *Disavowals*, as has become the broadly-accepted English translation), by the writer Pierre Mac Orlan, warns that the book evades all criticism and seeks to deliver itself from tradition. Autobiography was very rare among French inter-war women – and those that do exist are typically defensive. Was the genre inimical? Colette, in her fiction, famously warned the reader against 'facile referentiality'. Indeed, what can be more fixing (and potentially facile, in Cahun's case) than the pursuit of a narrative biography to construct a knowable subject? Leperlier is clear regarding Cahun's sexuality and attraction to Breton. He considers that her lesbianism was narcissistic, a regression, without providing much in the way of evidence for her supposed love of Surrealism's 'Pope' – though it is certain that 'Bob', Cahun's lover in *Aveux*, was real. Breton would, it was

said, quit his favourite cafe, Café Cyrano, on the arrival of Cahun and Moore. At best, or worst, he was what Robert Hughes in *The Shock of the New* called a 'touchy Pope' – though not all have interpreted him so benignly.

Frustratingly, however, an anti-fix agenda is no less fixing – and nowhere is this more obvious than with attempts to enforce present day, arguably postmodern concerns on an evaluation of Cahun's work. Still, if Cahun really was a series of constructs impossible to know, why are we Cahunians so interested – and how is it that a new set of constructs have been imposed on her life and work? Her surrealism, and gradual inclusion within the group, provides the key.

Cahun dragged her feet regarding the surrealists, a group she would eventually join in 1932. She met Philippe Soupault at Monnier's bookstore in 1919. He proposed she collaborate in the formation of *Littérature*, which he launched with Breton and would form the foundations of the movement. Cahun, intimidated, declined. It would take another ten years, and the intercession of her friends Henri Michaux, Robert Desnos, and Jacques Viot, before Cahun agreed to meet Breton and become officially affiliated with the group. Cahun finally met the man in 1932 through Viot, though it's certain she knew of him already. She even anticipated the surrealists: her doll self-portraits of the late twenties preceded Bellmer's 'Doll Series' of 1934; while her aviator image of 1927 is similar to Man Ray's portrait of Breton, taken in 1930. Cahun also personally owned first edition surrealist texts from the twenties and thirties. She admired Max Ernst and owned one of his photomontages, as well as a painting by Miró.

Why then the delay in joining the group? On publication of *Aveux*, Cahun conceded that she did not yet know her social role (and admitted that it should be postponed to the end of her life). Though Moore is designated the label 'moi-même', or 'the other me', in the book, there's certainly disagreement

between Cahunians regarding the extent to which Cahun's work was a collaboration *with* Moore – and in what ways. That *Aveux* was collaborative was hardly likely, however, given Cahun's paradoxical single-mindeness as both 'object' and 'subject'. The work is arresting no matter its authorship, and radically transformed the discursive, status quo, preservation function of the memoir. Cahun constructed a new kind of subject; rather than diarising the artist within an oeuvre via signature, Cahun dismantled literary genre, autobiography and its subject. Her signature, therefore, is a disavowal of identity, and the construction of an artist at the intersection of the real world and that of commodity.

The English translation of its title is also worth further consideration. A *Chicago Tribune* profile of Cahun and Moore from the time translated it as 'Denials' – which is what Monnier, who had originally challenged Cahun to write a confession, wanted. From first arriving in Paris and making her way to the rue de l'Odéon, Cahun clearly sought Monnier's acceptance and yet received only rejection – a result of her refusal to compromise, or a difference in taste, depending on one's point of view. Even so, when it comes to the title it seems likely that Cahun herself provided the translation, though the negation in *Aveux non avenus* suggests 'avowals not admitted' – hence, *Disavowals* – would be more appropriate.

Leperlier describes the book as 'an anatomy of the image', a borrowing from Bellmer, who, he argued, resembled Cahun more than the likes of Man Ray. The artist was known for his gender-bending antics – a far from unique trait among male surrealists, incidentally, with Duchamp's alter-ego Rrose Sélavy being perhaps the most notorious. Cahun's photomontages can equally be compared to Raoul Hausman and Max Ernst's twenties collage novels, Cahun producing all the sketches for her own work herself. In *Aveux non avenus* –

which translates, prosaically, to 'null and void' – the 'I' is ambiguous, unlike, for instance, the use of the first person in Rousseau's *Confessions*. The self is unnamed and ungendered, synergistic (in the sense that it was collaborative) and the work was part of modernism's interrogation of Enlightenment paradigms of thought. 'Each time one invents a phrase,' Cahun writes, 'it would be prudent to invert it to see if it holds up.' The 'I' also equals eye, echoing Bataille's 1928 novel *L'histoire de l'oeil*. For Cahun this particular eye/I is annihilated (and the autobiographical subject with it) – hence the cover plate for *Aveux*. If Cahun is 'a singular plural', in her words, then the plural included Moore – her other her.

The launch of the book, however – and the photomontage within – said it all. The display, in the window of the publisher, Editions du Carrefour, 169 Boulevard Saint-Germain, was meant to cause a stir; a declaration of the artist's public unveiling. The book itself was an expensive production, its quality praised by Albert-Birot in a letter of thanks on receiving his copy. Alongside it was Ernst's novel *La femme aux cent têtes*, the presence of which rendered the event a sort of exhibition. Notably, the same window display included the journal *Bifur*, edited by Georges Ribemont-Dessaignes – who'd introduced Cahun to Pierre Levy, director of Carrefour – and housed the one self-portrait Cahun published in her lifetime.

In *Aveux*, there is no transparency between artist and work. Assembled between 1924 and 1929, only some of it is in chronological order. Each chapter is concerned with an aspect of self, and the titles denote psychological states out of which the self is fashioned (fear, self-love, and so on). It's a tease, offering only the pretence of autobiography. There are eleven photolithographs of photomontages, plus a frontispiece and a plate at the start of each chapter, and Cahun is present in all. The 'I', however, is immediately thrown into question. The

frontispiece is signed, the only plate with a signature: *Moore*. A publicity poster said the plates were 'composed by Moore in following the author's designs'. Crucially here, as with the display in the Carrefour window, Cahun is the author.

Breton's 1928 novel, *Nadja*, is all about male desire and the power to transform this desire into art – a power residing solely with men. This surely frustrated Cahun as an artist far into a transition from symbolist to surrealist, but one who was also keen to explore her own desires. In *Aveux*, Cahun looks upon love as often unequal: 'Us. Nothing can separate us!' Yet *Aveux* is also Cahun's mirrored egoism. She imagines a relationship on equal footing: 'the ideal'. The goal, she states, is 'collaborative partnership' in love. Is *Aveux* then concerned primarily with an absence of fixity? As Cahun writes, toying with the reader: 'Individualism? Narcissism? Of course. It is my strongest tendency, the only intentional constancy I am capable of. Besides, I am lying; I scatter myself too much for that.'

The work encapsulates her stop-start digressions, the obstacles she faced in being a woman, a lesbian, a Marxist – and only then a surrealist. For Cahun to go beyond observer vis-à-vis the observed she turned to self-portraiture and the fictionalised memoir, and to a frankness of discontent coupled with an acknowledgement of aspirations. Is this reductive, missing the point that abstract self-portraiture is innovative and revealing of so much more than truth? Her *Frontière humaine* self-portrait, originally titled 'Que me veux-tu' – or, 'What do you want from me?' – is significant in its doubling, especially in the way it also represents Cahun's writing. Indeed, Cahun is often disguised in her photomontages, while her images, with few exceptions, don't employ nudity or mutilation – unlike those of other surrealists. When it comes to her self, she never quite bares all.

And nor did the surrealists, beyond the group's superfi-

cialities and taste for controversy. In the first Surrealist Manifesto Breton wrote pointedly, 'Our brains are dulled by the incurable mania of wanting to make the unknown known, classifiable.' *Aveux* is layered and at the same time unclassifiable. Bataille was a strong influence: his idea of the 'informe', which he defined around the time Cahun was shooting *Human Frontier*, was a device to declassify. In *Aveux* Cahun embraces Bataille's declassification: she uses the verb déclasser ('to downgrade') but also refers to that which is not readily classifiable. She writes, 'I'm mad for exceptions … Thus I downgrade, declassify myself on purpose. Tough for me.' Whatever Cahun thought of her work, however, clearly Breton was a fan. He famously wrote to her in September 1938: 'It seems you are endowed with extensive powers. I think (and will keep repeating it to you) that you must write and publish. You know very well that I consider you one of the most inquiring minds of our time (one of the four or five) but you find pleasure in keeping silent.'

Human Frontier is exemplary of both styles of surrealist photography – the manipulated (informe) and the realist (straight). The image – a double self-portrait, her head shaved – was reproduced in *Aveux* but also on the cover of *Frontières humaines*, a 1929 novel by Ribemont-Dessaignes. That the title was so close to that of Cahun's self-portrait was no coincidence, for Cahun had helped with the novel's design. More to the point, perhaps, the book argues that there are always two aspects of the self, a fact that precludes the possibility of both loneliness and oneness. Ribemont-Dessaignes also employs the metaphor of the glove, a surrealist trope, to demonstrate the dichotomy between the outer shell and inner content.

For Cahun, though, her photography too resisted all classification. Indeed, what began as public – at first her photography, and later her writing – became increasingly private, and was shared only with Moore and a few friends. It's

reasonable to assume a licking of the wounds taking place; Cahun, excluded by those from whom she sought inclusion, decided to go home and take her ball with her. But that was to come only later. As the twenties became the thirties she was, in her writing, haunted by the ghost of the other. 'The question of autobiography haunts surrealism,' according to Breton. No matter how hard to pin down, however, the ghost was to be interrogated – the opening question of Breton's *Nadja* is 'Who am I?' Cahun writes in *Aveux*: 'No. I will follow the wake in the air, the trail on the water, the mirage in the pupil ... I wish to hunt myself down, to struggle with myself.' But this is elusive. The 'mirage in the pupil' is only a glimpse, or a ghost, of her self.

Other influences 'haunt' *Aveux*. Nietzsche was widely read within the symbolist fraternity, particularly his notion of the self-destructive genius. Both he and Cahun were also concerned with social dynamics and religion and their role in defining an individual's morals. Though Nietzsche relies on hierarchy (*Der Ubermensch*) and feels superior to humanity, while Cahun feels apart, *The Antichrist* is cited in *Aveux* as the only thing that still 'bothers us'. Nietzsche argues that morality departs from reality and is used by the church to control, while Cahun, in *Aveux*, attempts to position herself in society: she retracts into the self, then deduces that God is within the self; hence, 'Dieu x Dieu / DIEU = moi = Dieu,' God is reduced and resides in the individual. God is dead (again), the question of self is now temporal – if not quite answerable. As she surmises at the beginning of that chapter, 'The siren is beguiled by her own voice.'

*

In 1934 Cahun wrote her most important political work, *Les paris sont ouverts* – translated as 'place your bets' – which

outlines the role of the artist in revolutionary times. 'Indirect action to me seems the only efficient action, from the point of view of propaganda and poetry,' she writes.

Les paris was originally written as part of a report for the literary section of the Association des Ecrivains et Artistes Révolutionnaires (AEAR) in February 1933. Cahun had joined the organisation in 1932, on aligning herself formally with Surrealism. The notes and the second half – written in the wake of 'L'affaire Aragon', during which Louis Aragon moved closer to Stalinists within the Communist Party – highlight the weaknesses and contradictions of his writing and opinions, and were added a year later. *Les paris sont ouverts* was therefore a product of tensions between official Communism and Surrealism, as well as a personal statement.

Poetry is not propaganda; for Cahun, the latter is 'revolutionary masturbation ... exhorting action when none is possible or desirable, so that when the moment comes, as in making love, the bolt has already been shot'. Direct action by contradiction, by provocation, requires 'an unthinking reaction' and reinforces 'the binaries of "right" and "left"' – thus, it is also 'a method of cretinisation'. This evokes the surrealist concept of the revolutionary power of the unconscious. She continues, 'This is why I think communist propaganda should be consigned to the directed thought of consciously political writers, that is, journalists ... While poets act in their own way on men's sensibilities. Their attacks are more cunning, but their most indirect blows are sometimes mortal.' *Les paris* was later described by Breton as providing 'a truly evocative image of the era'. He hailed Cahun's pamphlet as the most significant and important of its time.

Cahun did not publish in Surrealism's journals of the thirties. In 1935, Cahun had joined Bataille's Contre-Attaque, an organisation designed to counter the growth of fascism and the Popular Front. (It's doubtful that workers paid much

attention to this most arcane of endeavours.) Breton joined, too, having broken with the AEAR in 1933. The group was dissolved the following year, but the coalescence of Bataille, Breton and Cahun is significant. Leperlier is principally interested in Cahun as 'one of the rare women who actively participated in this [Surrealist] movement in its most critical and complex years'. Where, in the twenties, she had championed the literary community only to be slighted, in the thirties she finally found a role – and it was with the surrealists.

To align with the AEAR was in itself a move away from self-interrogation towards political engagement, and it's clear that during this period Cahun was at the peak of her political powers. For Bataille, whose *L'histoire de l'oeil* was an important reference point, revolution, as with art, was 'expressed in periods of crisis by those who write'. He was in favour of force but not 'the spontaneous reactions of the street'. Leadership was to be found in those who sought to 'deliver the world from its exhausting boredom'. Indirect action, for both Bataille and Cahun, was always preferable – where possible, of course. In 1936, during Cahun's most intensively involved period with Contre-Attaque, the AEAR's chief publication had asked its disciples, 'For whom do you write?' Cahun answered, with a flourish: 'I wish to write above all against myself.' The political role of poetry was therefore destructive, made by all, and part of a progression towards the artist's dismantling.

If there was a moment in Cahun's life when she ceased to be an artist and became something else – indeed, something more – then it was this. In May of that year Cahun had produced items for the Exhibition of Surrealist Objects at the Charles Ratton Gallery, Paris, as well as an article (titled 'Beware of Household Things') in the special issue of *Cahiers d'Art*. She also contributed to the International Exhibition of Surrealism at the Burlington Galleries, London. Her object for

the expo bears witness to 'the fragility of hopes for supersession of bourgeois culture'. This was to be the movement's last political statement before being re-orientated as a modern art movement, and its failure preceded a retreat by Cahun. When Contre-Attaque disbanded in 1936, Cahun chose to align neither with the Communists nor the Popular Front – and instead reached out for something altogether more radical.

But if Cahun's immersion in revolutionary politics had been overdue, it was far from unexpected. In the late twenties Cahun enjoyed friendly relations with the communist editors of the journal *Philosophies* – Pierre Morhange, Norbert Guterman, and Georges Politzer – as well as with some former surrealists, including Ribemont-Dessaignes and Robert Desnos. 'I spent thirty-three years of my life desiring passionately, blindly, that things be different from what they are,' she writes in her 1948 *Le Muet dans la melee* – the work only made available by Leperlier in his edited collection of her writings. This was the culminantion of a steady though ineluctable shift from idealistic and playful flirtations with style – most notably symbolism – to a Marxist materialism inimically opposed to fascism. Indeed, Cahun's name appears with the surrealists who signed two important tracts of the AEAR: 'Protest!' in March 1933, which attacked the growth of Nazism in Germany; and 'Against fascism but also against French imperialism!' in May 1933, which attacked capitalist exploitation. She was, however, too ill-at-ease for the authoritarian AEAR. She would quickly join the Trotskyists within the organisation, surrealist sympathisers all of them.

Cahun's only explicitly Marxist work, *Le Paris sont ouverts* was also firmly rooted in surrealism. The front cover included a quote by Breton and the back farcical remarks by Aragon. She was ahead of the group politically as early as 1934 (they failed to break with Stalinism until 1935). Not unlike the

Breton-Trotsky manifesto of 1938 – which declaimed 'Absolute freedom for art!' – Cahun's pamphlet was also influenced by a Tzara article in *Le Surréalisme au service de la révolution* of December 1931, which argued for 'the Romantic definition of poetry and the surrealist revolution of the mind against the old and superseded understanding of poetry as simply a means of expression'. Poetry, for Cahun, is above all an agent of change – like science and politics – and the second half of *Les paris* is her 'attempt to interpret poetry dialectically'.

Les paris contained some of her most consciously Marxist pronouncements on everything from art to the man in the street. Though she was opposed to universal suffrage – at bottom because of her mistrust of the crowd – attitudes towards her changed following its publication. Breton called it 'remarkable' in his essay 'Qu'est-ce que le Surréalisme?' and, a year later, in *Minotaure*, again referred to the text: 'In the recent polemics with Aragon, Claude Cahun has presented conclusions that for a long time will be the most valid.' Despite Leperlier's contention that Cahun and Breton were lovers, their only real common ground was Marxism. The pamphlet fully supported Breton's views, as well as those of his closest disciples. Cahun nevertheless steadfastly refused to sign Surrealism's declarations in 1934 and 1935. Only when she joined Contre-Attaque did she argue, like Trotsky, that 'revolution must be permanent or it will not be viable' – and only then did she sign up, literally, to the cause.

Her contempt for the suffrage movement was only surpassed, publicly and privately, by being at odds with herself. She boasted of her dilettantism, of her intellectual infidelity, of her refusal if not to be fixed then to commit, one way or another, either to a singular art or collective cause. For Leperlier, however, she is to be considered as 'the only female surrealist photographer': he argues that Lee Miller and Dora

Maar were only 'briefly associated', and others merely associated as mistress, as object. But it is tempting to take the argument further. 'Photographer' can be dropped completely and the sentence adjusted to render the statement more emphatic, if not quite accurate: Cahun was the first female surrealist.

Of course, women were only recognised as part of Surrealism in the eighties – when Cahun was, belatedly, included in the official histories. In no time at all Cahun's work was simultaneously and rather neatly usurped to fit with an identity politics agenda. It was certainly the case that, while male surrealists obsessed over objectified woman – Breton with his 'convulsive beauty', Max Ernst and Man Ray in their fetishising of the feminine form – female artists had to submit or be marginalised. This led them to use irony and confrontation: Meret Oppenheim employed masks, Frida Kahlo and Dorothea Tanning masquerade, while Kahlo doubled her 'self' in *The Two Fridas*. Like Cahun, the work of these women doesn't translate easily to postmodern times. Unlike them, it's possible also to locate in Cahun's work a surrealist conception of Marxist politics – for she explicitly believed social change would bring about reciprocal love, that it would suppress capitalist production and rules governing ownership.

Surrealism was, however, a 'men's club' – or rather, a crisis of masculinity. Man Ray and Duchamp cross-dressed in order to feel the male gaze; Breton, famously homophobic, obsessed over 'the homosexual milieu' and hated Jean Cocteau (although, perhaps less for his sexuality than for his fame); *Bride Stripped Bare*, again by Duchamp, and René Magritte's *I Do Not See* show a lone female vis-à-vis group of males; and, while Man Ray's *Waking Dream* shows a woman recording man's dreams, she doesn't have her own. And yet, Cahun's work fits squarely within the core of surrealism, with its

antipathy to bourgeois morality and its experimental approach to fixed poles of gender and sexual identity. Cahun was the only one within its ranks not to have conformed to a fixed type of woman; namely, that of erotic spectacle. She utilised its tropes – mirrors, masquerade – while critiquing its fetishisation of the female body. For Cahun, surrealism served as the principal means by which opportunities for expression could be kept open.

Once more a deviant among deviants, it's nevertheless quite reasonable to wonder how Cahun could be both unidentified and missing for so long from the history of the movement. She is absent from Maurice Nadeau's *The History of Surrealism* – first published in French in 1944, and in English in 1965 – as well as René Passeron's *Encyclopédie du surréalisme* (1975) and Édouard Jaguer's *Dictionnaire général du surréalisme et ses environs* (1982). Leperlier suggests that Cahun's 'profoundly introverted attitude' explains, in part, her historical occlusion. Indeed, her sexuality wasn't enough to make her an outsider – but what of her gender?

What makes Cahun interesting, above all the other women of the Left Bank, is that she was assertive as woman *and* man. Her either/or gender can certainly help to explain her disappearing act. A 1936 Breton lecture in London was mistranslated, referring to Cahun as 'he' (while Jaguer's *Dictionnaire* referred to Moore as 'Henry'). Simone de Beauvoir writes revealingly in *The Second Sex*, of Breton: 'Breton does not speak of woman as a subject … Truth, Beauty, Poetry – She is All: once more all under the form of the other, All except herself.' Quite apart from her female contemporaries – artists like the somewhat reluctant surrealist Leonora Carrington, who portrayed women more conventionally – Cahun created a sort of third, or 'Uranian', way. She also, paradoxically, recycled and reused her images – as if through an augmen-

tation of selves her one true self could be found, which of course it could not. In this way Cahun's body was spectacle, evoking the predilections of fellow surrealists, but it was entirely of her own creation. More to the point, her process of becoming constant while remaining incomplete did not fit comfortably with Breton's concept of 'Woman' – undermining, at the same time, any suggestion that Cahun was 'the first female surrealist'. For women to be fully accepted as part of the group, they had to sleep with one of the men (as was the case with Dora Marr, Lee Miller, Dorothea Tanning, Nusch Eluard, and so on). The surrealist model for female emancipation was simple: muse-model-mistress. 'Artist' only came after, and this would never be enough for Cahun.

So, what of the misogynistic traits of Breton's men's club? If the surrealist feared castration and therefore disfigured and deformed the female figure to reassert his ego, then surely Surrealism was above all things reactionary – a reinforcement of the power relations of male dominance and patriarchy, which were, after all, social constructs. How did Cahun square herself with this? She didn't have to, for the marginalisation of women artists was arguably as much about competence as conspiracy. Between 1924 and 1933 – in twelve issues of *La Révolution surréaliste* – a solitary, untitled poem by a woman was included. It was written by Fanny Bezmos, who is mentioned in *Nadja*. In *Le Surréalisme au service de la révolution* three women writers each appeared once, whereas just three visual artists contributed (Paul Eluard's wife Gala, and Max Ernst's wife Martie-Berthe Ernst). Only from 1935 were women included in exhibits and pamphlets – Cahun was one of them. We might look to the epoch for clues. De Beauvoir famously hailed Colette as the only female writer of note in the male-dominated modernist milieu. It's true that there were more female bestsellers in seventeenth- and eighteenth-century France than in the nineteenth. Can it be there simply

weren't that many outstanding French women writers in the first half of the twentieth century, that Surrealism accepted women willingly – but only when the group became weaker?

No matter, for by 1937 the group wasn't alone in finding itself fragmented and under threat– as was the case for the whole of Europe. Joining the anti-fascist group FIARI (International Federation for an Independent Revolutionary Art) was Cahun's last known political activity in Paris, and the rise of Nazism meant that she left, with Moore, for Jersey in 1938. When the island was invaded by the Nazis in 1940 the couple refused to move to England and decided to remain. Cahun loved the peaceful island she had visited all her life, and the couple soon made it their home. The house in which they lived was nicknamed 'the farm with no name'; its real title, 'La Rocquaise', derived from 'rock', loosely translated as 'the one made of rocks' in which 'the one' is an object or, if read as a pun in French, a tough, hardy woman.

Its meaning was apt, to say the least.

*

How best to describe Cahun's resistance activities on Jersey, where, alongside Moore, she set about subverting the Nazi occupation through a carefully choreographed, disruptive propaganda campaign? Was it a sort of culmination of knowing her 'true self', or should we see it as just another part she played, a mask like any other? As she herself wrote, 'Beneath this mask, another mask.' Was it in fact a progression from the early photo-play of two defiant lovers, via a then fragile dream of political community in Paris, which concluded with the couple acting as one (as if many) in Jersey? Or should the resistance be placed in context of her earlier work, especially her writing?

Resistance was, in Cahun's own words, 'the logical conse-

quence of my activity as a writer during the Popular Front period'. Cahun believed that 'the working class should be linked by international solidarity and not nationalism' and advocated both defeatism and 'an aggressive pacificism'. German workers were for her the victims of Nazism. But as a woman and a Jew, no political cause could rank more highly than courage – which is surely the only word to describe the couple's actions.

Cahun's war notebooks are now missing. Much of her work, especially writing, was destroyed when her Jersey home was ransacked during the couple's eventual arrest in 1944. What did survive, on cigarette boxes and graves, was the phrase 'ohne ende' – meaning, 'without end'. 'For them the war is over,' the couple joked darkly. Cahun came up with the idea for the nameless soldier ('Der Soldat ohne Namen'). Moore spoke German and insisted that 'namenlos' (meaning nameless) was more appropriate grammatically, but in Cahun's incarnation the soldier is 'irreverent' – unlike the emblematic 'Unknown Soldier' of the First World War. Much like the characters of *Héroïnes*, 'Der Soldat ohne Namen' provided a cover for the couple to carry out daily acts of subversion. The pair utilised *objets trouvés* in a series of non-violent though incredibly daring stunts – surrealist and even owing much to Dada – designed to disrupt and disquiet the occupying forces. Only fifteen propaganda texts survive – including a photo mash-up of Wilde with German soldiers – which probably represents only a very small part of the actual production.

Alarm. Alarm. Why? While Berlin burns, while our towns fall in ruins, while the foreign workers & refugees plunder our villages.

ALARM. What for. So that the officers when frightened like in Stalingrad and Tunis want you to protect them with your lives,

so they can escape.

ALARM. What for? So that you don't have time to think.
WHY...WHY...
SPECTRE...
Because you have all been 'brainwashed'. Yes we were in 1918
and this time it will be longer and more bitter than ever.

Read every week the paper for soldiers without a name ('die
Zeitung der Soldaten ohne Namen'.)

While Cahun retrospectively cast doubt over her success
when it came to defining 'good propaganda' in her
Confidences au miroir, the confession dated 1945-6 and
dedicated to Moore, we should be in no doubt that the resistance of these two women was remarkable. There was no
chance of escape from a tiny island, densely filled with
German troops. The population was small, and, as the
historian Charles Cruickshank explained, 'Every man,
woman and child could have been gassed and incinerated in
a single day in one of the larger and more efficient German
concentration camps.' The threat of punitive measures was
therefore very real, and much of what little resistance there
was comprised escape acts. Nevertheless, Cahun and Moore
warrant just one small paragraph in Cruickshank's book on
the island's occupation, where their relationship is mistakenly
likened to that of blood relatives. 'Shortly after the invasion of
Europe two Jersey half-sisters, no doubt thinking that the end
was in sight, began to type messages inciting the troops to
surrender.'

They were more than likely caught as a result of the
shopkeeper who sold them cigarette papers. Cahun tried to
save Moore, claiming sole responsibility and even confessing
her Jewish heritage – which she had kept hidden until then.

When they were originally sentenced to death, it was to be by beheading. The couple attempted suicide by cyanide on arrest, but failed – which ironically saved them, as they remained too sick to leave the infirmary when a shipment of prisoners was set to leave that day. Having been sentenced to six years for listening to the radio and death for distributing messages, Cahun, contemptuous in court, asked which sentence they would serve first. They soon discovered that a number of German soldiers had also been jailed for insubordination – for which the couple blamed their own actions. They refused to sign an appeal for pardon – thus remaining in prison from summer 1944 (when France was liberated) until the 8th of May 1945, the last day of the war.

In her prison diary, Cahun is typically magnanimous – but also playful. She describes, with humour, the washing facilities 'as old as the building itself'. 'They would have delighted an antique dealer,' she continues. Prisoners had to carry heavy basins, which held seven or eight pints, around the cells. 'By the time it overflowed, if the wardens were alerted, I should be well past human interference.' The toilet at the trial was 'set in the wall' between floors. They had to use it in full view of 'the crowd in the hall' as only one person could fit inside and so the door remained open. The nurse was sympathetic, and allowed Cahun to close the door – 'but please don't push the bolt!' she added. 'Don't worry, I said, we want to see the end.' Of her counsel, asking her point of view: 'If you had conducted your own case, he asked, what would you have said?'

I knew that I could not resist the temptation – though it meant alluding to recent war news of which we were supposed to be totally ignorant, and might perhaps lead to trouble later. The chance of forcing them to acknowledge us on their own ground was too good to miss. I took a deep breath, and plunged in. I

think, I said, that I would only have asked you one question: 'If
at this very moment you were told that, in Aachen, two German
women were doing exactly what we have done here, would you
blame them?'

Details of Cahun's resistance activities were discovered in her
surviving notebooks and in letters to her friends Gaston
Ferdiere and Paul Levy. Writing to the latter, she alludes to
her sexual preferences as one of the motives for her revolu-
tionary commitment. 'I'm an asocial rebel and a revolutionary
dreamer, and do not fit any political party; my religion is
paganism, including inspired figures such as Socrates,
Buddha, and Kropotkin; and my (dialectical) method of
thinking is taken from Heraclitus, Hegel, and Marx.'
Although a pessimism derived from Nietzsche and
Schopenhauer was prevalent in her work to the very end, she
never gave up. 'My "despair" did not prevent me from acting
under the sign of crystal and the blue of dawn.' Cahun had
originally wanted to shoot the Kommandant, and even went
into the woods with a revolver for target practice. Moore
seemingly talked her out of it, and the two committed
themselves to what Cahun later described as 'revolutionary
defeatism'.

On fleeing fascism in the thirties, Cahun had nevertheless
tried to retain links with the Surrealist movement. As well as
joining FIARI she signed the last written declaration of the
group before the war and its dispersal in 1939. Years later, on
the 3rd of June 1953, Cahun and Moore left Jersey for Paris. On
the 7th of July they returned to La Rocquaise. Cahun had met
with Breton, Benjamin Peret, Meret Oppenheim and Marie
Čermínová Toyen at the Café de la Mairie, and the couple
even looked for a flat in Montparnasse. Cahun's chronic
health problems had clearly worsened during her time in
prison. (In one diary entry she complains of a constricted

lung, exacerbated by the plastering of the cells: 'How this dust was penetrating our "coffins"…') Her failing body therefore prevented the return to Paris her mind so craved. Letters to Breton and Jean Schuster confirmed this thwarted desire, and a 1951 note to Barbier indicates her ill health.

Exhibiting a schizophrenic's pathology towards multiple identities as an alternative to no identity at all, Cahun wrote in *Aveux*: 'There are as many ways of being as stars in the sky.' An anorexic who lacked a mother in turn fetishised the father (Breton) and the perfect couple (with Lamba, who visited Jeresey alone, as a new mother, in May 1939). A well-known portrait of the pair, taken by Cahun, is dated 1935-6 – and Cahun also knew Beatrice Wanger (otherwise known as 'Nadja'). But a return to Paris and Breton was not to be.

'The Soldier with No Name' – the inherent negation of 'with no', as with *Aveux non avenus*, is in my view preferable to that of 'without a' – was Cahun's last mask. She would use her real name until her death. Characteristically, in her 1945-6 confession Cahun seems to feel responsible for involving Moore – but maintains her as an equal all the same. The resistance was, crucially, 'an individual struggle of two', and the couple lived quietly until Cahun's death on the 8th of December 1954 – a year after their return from Paris. In 1972, after a tired and arthritic Moore committed suicide, Jersey resident John Wakeham passed a collection of Cahun's belongings to Jersey Museum Service.

The material at Jersey Archive is fascinating though, for Cahunians at least, poignant. Cahun's will was signed on the 16th of June 1941, 'my friend Suzanne Malherbe' named Executrix. Henri Michaux was also named in the case of Moore dying first, while Cahun's estate was to be bequeathed to Moore 'absolutely'. Cahun's Aliens' Registration Card gives further, enlightening details. 'Lucie' (she signs 'Lucie Schwob') gives her profession as 'Independent' and

relationship status 'single'. The couple stayed at St Brelade's Hotel on every summer holiday together (a series of visits stretching back to July 1922, and ending in September 1934). The next time she was in Jersey was the 4th of April 1939, when she registered at La Rocquaise. This, clearly, was when the couple moved to the island permanently. Last of all in the archive is Cahun's tiny obituary, from the *Evening Post*. She is described as 'a brave lady' and one of 'two brave sisters', the journalist speculating that 'few people on the island would probably connect the [resistance] activities with the name of this recently deceased woman'.

It's taken six decades, the length of Cahun's lifetime, but to the 'few' more have been added – a collective of multiple and disparate selves, united not by a singular mode of thought, identity or agenda, but an addiction: to art for art's sake; to the most unknowable of all things; to a life lived without compromise, with courage and conviction. To Claude Cahun.

For an ever growing number of us, Cahunians one and all, she is no longer *der soldat ohne namen*.

Acknowledgements

I want to thank Philip Hatfield; fellow Cahunians, especially Lizzie Thynne at the University of Sussex, Louise Downie at Jersey Heritage, China Miéville and Lauren Elkin; everyone at the Jersey Archive; the Jeu de Paume in Paris, as well as curators of its 2011 Claude Cahun exhibition, Juan Vicente Aliaga and François Leperlier, both of whom kindly answered my questions. Monsieur Leperlier deserves enduring gratitude. Without his devotion to championing the life and legacy of Claude Cahun, she would, I'm sure, be forever lost to us all. Thank you to the Society of Authors and K Blundell Trust for supporting my research and the completion of this book. And finally, thank you to John Hunt, Tariq Goddard and Zer0 Books for publishing it.

Contemporary culture has eliminated both the concept of the public and the figure of the intellectual. Former public spaces – both physical and cultural – are now either derelict or colonized by advertising. A cretinous anti-intellectualism presides, cheerled by expensively educated hacks in the pay of multinational corporations who reassure their bored readers that there is no need to rouse themselves from their interpassive stupor. The informal censorship internalized and propagated by the cultural workers of late capitalism generates a banal conformity that the propaganda chiefs of Stalinism could only ever have dreamt of imposing. Zer0 Books knows that another kind of discourse – intellectual without being academic, popular without being populist – is not only possible: it is already flourishing, in the regions beyond the striplit malls of so-called mass media and the neurotically bureaucratic halls of the academy. Zer0 is committed to the idea of publishing as a making public of the intellectual. It is convinced that in the unthinking, blandly consensual culture in which we live, critical and engaged theoretical reflection is more important than ever before.